LIGHT LIFT

S.D. Wojciak

authorHOUSE®

AuthorHouse™
1663 Liberty Drive
Bloomington, IN 47403
www.authorhouse.com
Phone: 1-800-839-8640

Published by AuthorHouse 10/23/2012

ISBN: 978-1-4772-7444-6 (sc)
ISBN: 978-1-4772-7445-3 (e)

Library of Congress Control Number: 2012917917

*Any people depicted in stock imagery provided by Thinkstock are
models, and such images are being used for illustrative purposes only.
Certain stock imagery © Thinkstock.*

This book is printed on acid-free paper.

Love Grows Love

Day sky,
Light the World
Shine, rays golden upon gardens
Grow love.

Love grow
Gardens upon golden rays, shine
World the Light,
Sky day.

Love Grows Love.

A Year Long "One Night Stand"

———————————— ✿ ————————————

Darkness fled from the match,
leaving your eyes and my reflection
caught in soft marmalade light.

Warm-skinned, we inhaled each other,
until our candled shadows overlapped.
We swam in dark shapes, wading through dim fear
and drowned our separate selves.

The wall stilled, and we slept cast as one.
Morning peeled us apart.
Our single shadow broke in two.

A Dark Room

You left.
Now the

Urine stained sun
Splinters my open blinds
And I can only sleep on one side
Of the bed.

I hug
Then strangle
The hole
That was you.

A deep silent shadow
Rises
And walks away.

The Buddha's Tongue

Emerald, Gold and Pearl... The Precious Vase –
 Buddha's Neck.
Treasure... A vessel.

The Protection Parasol – The Buddha's Crown,
A protective umbrella,
Liberating from suffering.

The Golden Fish – The Buddha's Eye
Wisdom and Compassion,
In one's quest for freedom...Free like a fish in a pond.

The White Lotus – The Buddha's Tongue
The resilient Lotus Remains pure and white in muddy
 places.
Purity of mind, body and speech... Wholesome deeds
 are seeds.

The White – Conch Shell – The Buddha's 3 Necklines
Traditionally blown as wartime warnings...
Awake!

Human Culture Transforms... Evolution and Highering
 our energy levels,
Ending the cycle of birth and death.

As we live in the physical and afterlife dimensions
In Unity, and as purely spiritual beings, here on earth in
the physical.

The Endless Knot – Buddha's 3 Hearts, No Beginning,
No End...
Boundless, Permanent Awareness of Buddha...
Wish to share Buddha's Awareness.

The Victory Banner – This is Buddha himself,
Fulfillment,
Quest for Supreme Enlightenment,
Willingness to the Universe
to overcome negativity.

The Dharma Wheel – Buddha's Palms,
Has 8 Spokes... The Eight fold path,
Right moment,
Right now,
Esoteric unseen forces, Sacred symbols.

Awake I still.
No longer restless,
Peace finds Me.
Peaceful Universe!

Eyes

Marbles fill a glass jar,
The lid still air tight.
Blinking blues, greens, and browns
Lay quiet, hard, contained.
A deep vacant Universe
Motionless...
Distance hides a chip.

An Aged Photograph

Handing a faded young image
of herself (holding me)
to me,
we exchange forms.
My cheeky balloon face of then
matches that of hers
now.

Then,
silouhette smooth angles
shaped a face
my profile traces.
Her Sandy-brown hair brushed waves
in waist deep oceans, then.

Now, short autumn reds
jacket signs of (too early) winter greys.
Weighty Buddha breasts huddle
above a pillowed belly.
The flesh sinking 'round
both neck and chin vacuum her
nose to smallness, yet

wrinkled arrows point to two
pinwheels of greens and blues
that reflect a merging
of then and now—
my own image in her eyes
both then and now.

The Seperation

Today I checked my shoes to see if
they had curled up again.
Yes,
I saw in the thought of this one gesture that
I am the fooled
jester.

Only the hat is missing.
I lost it on the turn.
Two new bald tires
slid nail-scratching the back road.
Seven hundred and thirty seven days
of miles
of dust
blown away.

The hat, too…
And then somehow the scene changed.
Love bended comfortable.
The screech fell inside
and pushed silence to fill the outside.

A permeable membrane…
Perspired liquid overwatered itself
and wilted, bloated.
The heated blister pin-popped.
The worn pair was thrown away, unlaced.

Drum Bust

The junkies sat in a circle
slapping skin on skin
to wake the veins,
to shoot up craved heart beats.
Rhythm was laid out in lines
and sniffed by fiending snares.
Bongos rolled and smoked high beats,
congas coughed bass pulses,
while small bell pills were popped periodically.
The room broke into a speedy sweat,
the drum squad rushed in…
nailing the addicts red-handed.

Muddles

———— ❧ ————

Size tight three
red rubbers
paddling size
twenty-three puddles
(leaving half-prints
in warm mud
with no hints
of WHO).
Sixty-three giant steps,
rain washes all but two.

———————————————

Family Captives

Blindfolded, she hid
Death's stiff shame,
banned my funeral-virgin sight
from the corpse show and
left Grandma
unburied to a silenced memory.
After all, 4 and 1/2 was too young
for the main event.

But, the circus continued.
The ringleader was dead.
The lions were drunk
and the tamer, untame.
Mother dodged the knives.

The doorbelled procession dragged in
dried autumn and thirst
quickly quieted by feast
and spirits (for the living).

Tradition filled each attender's cup
with wine and relief
in the name of the cross.
I was allowed no seat
in this celebration
(of Christ's new bride).
Squinting through child-binoculars,
I witnessed the closing ceremony.

Mother
dropped her shield
and battle-broke the bottles.

The room stain-soaked in silence…
until she took to her exit,
the finale still to come.

A door and midget fists
clapped and quick-kicked
against an instant of crisis
slowed by weight.

A newly towering voice
reached her ear
and unlocked.

Death and I
stared in from out.

Shrunk with
fallen pills…
blues and pink's…

She looked out, then
slow
lifted me
whispering gratitude
and my importance to her life
and my importance to her living.

Lover

Like a steel rushed train,
you rammed my walls,
opening me to love's dark descent.

One night turned to months,
then, flipped to years.
We shared most mornings
and nights. We became each other's skin:
pillow talking and laughing and crying and loving and
 dying
and fighting and making up.

Making up for all the absent love,
making up for all the bad love
that turned to nightmares
that haunted our bed
that had nothing to do with our love.

And you cursed the bastard's existence—
his existence alive
in my resistance to you,
in my closed legs.

But, one night turned to months,
(and you grew tired of him)
then, flipped to years
(and you closed my open legs). Now,
I curse the bastard's existence.

Last Will and Testament poem:

Giving the Bride Away or The Death of a Hetro

———————— ⚭ ————————

My "Adam and Eve" earth's eye
Takes a last blink:
The snowflake-white veil melts
And reflects clear hardwood,
For Mom.

Dad's old <u>Game of Life</u>
Rests in the closet.
I interrupt to hand dust and slow shake—
The box rips and rattles.
Baby-blue and pink families
Drop from tight seats
Sing-tapping against the board.
A straight path map
(From A to narrow B and A to Z)
Stays jaw locked in the glove.

I leave it there,
For Dad.
I leave what I am not
To nothing. I give
The Bride away
To listen to the shape
Of my heart's design when
My is left to self.

The A-Molecule

———————————— ⚘ ————————————

I wake squinting.
My lungs are pasty.
I understand I should quit smoking,
but I walk the puppy,
and think about that in steady drags.

As we tailwag down the sidewalk,
I remember... Alex smokes, too.
I think about her some morning walks,
think how far she's walked. And so fast.

She'd drink 3 cups of coffee
5 minutes after the alarm.
I know this because I've lived with her.
Actually, I stayed at the house she stayed in
with that boyfriend.

The "boy" was twenty years older,
but he brought her flowers
and bought her socks.

She loved new clean socks,
but always wore one pair for
at least 2 days.
It was a habit.

Back when she lived on the streets,
She'd wear 1 outfit for1 week, at least.
Then I lost track of her,
only knew she was somewhere in the Bay Area,
hanging out, smoking.

The leash pulls back my arm and
suspends my next step. Below my smoke,
the puppy crouches almost sitting. Steam rises
from behind her three month old rubbery limbs.
I'll leave her sculpture there.
I figure their rain will melt it, good fertilizer.

Just last week while
driving home from the sculptor's and my
first road trip together,
I stopped the Toyota and
ran to her through traffic.

She uncrossed her legs
and bounced up to greet me.
Then, instinctually,
she bummed a cigarette.

We both lit up and
blew thick warm fog at each other.
She followed me back to the car
to meet the new pup
saying "Its been soooo long"...Etc....Etc.
Blah, blah, yes almost a year.

Store lights strobed
Blink-winking at her:
Knit stockings – red,
mini – shark black,
slinky rayon shirt – grey,
thrifty heels – used black
lipstick – shady red.

We used to call her the A-molecule
because she is "so Alex."
No doubt, these 2 goggling men by her side
mustached and vest jacketed,
could not know they were bristles on her brush.

She is a painter
painting another world,
pictures far from her mother's Castle.

She looks for the push-cart
underground beneath the streets
and dips into its knowledge
like a bucket full of dye.
Immersed, she disappears.

Vanity

———— ❧ ————

Dishwasher-clean souls
"Pac-Man" desires
Hip hop hot scotch
Educated—
Liars.

Victoria's Secret silicone
Glue and press-on smiles
Butterflies in zip locks
And beauty in a box.
What more could you need?
But a dead shoulder fox
to heed the Ego feed.

———————————————

Jealousy

Slaves to diamonds
in copycat suits
sneering at passers
in workman's boots
who, living day
by blue-collar day,
doesn't have too much class
to flip another coin
to a drunk flat in the grass—
chained to the street
by a bottle.

Nita

Behind a desk
Sits a sacred sacrifice to her art—
Counseling transcendence
With Swift Divine Grace
To the battle-damaged
To the humbly distressed
She invites perfect travel
Into the Light of virtue harvest.

I mutter heart speech…
She encourages my submission to Spirit
To arise, overcome and defeat
Unsatisfied cravings
Unfit (within)
To the Present.

We exert Soul through eyes
And I am fixed on deliverance,
Exerting mind strives
With the option to never retreat.

Shovel Handed

God's upset.
His hat's too tight for his head.
His skin sun blushes.
His teeth itch-crave a hard nipple.

An unguided orphan rock cradled
In a sand and cement lined box
He calls "his."

Tonka trucks palm push Lincoln logs,
Grinding them aside.
Weeble wobbling plastic people
Shoot uncapped guns.
He plays.

Granite pebbles smooth, flat-faced and sterile—
His desert spread decadent with overplay as
He cat-buries the past feces' corpses.

Unaware of potty training,
He flings a landfill loaded diaper to hill
The padded surface.
Asswiped concrete
Layers his loneliness
As He hums, "Halleluja, hallelujah."

Still Restlessness

Still Rest Lessness To Search… For a spiritual unfolding.
Spiritual unfolding, Journey led forward by mystery,
Awakening to coincidences!

Pondering spiritual dimensions… Phenomenon not to
dismiss.
Synchronicity… Evidence of a divine force?
Purpose, Destiny and Mysterious Providence—
Keep Awareness fully operative in the Present.

What will transpire that shall shape Life's directional
desire?
Create a more complete worldview… The real nature of
our Universe.
Run from deep existential craziness! Find true Spiritual
oneness.
Science by itself, is devoid of Spiritual Mystery.

Find a more spiritual life view.
Universe of dynamic energy, Field of Sacredness, I sense
you!
Project your energy, Focus attention in the Ultimate
Direction.
Energy will flow, blow, go, and come back – Immutable
Natural Laws.

Run from the illusion that the Universe is devoid
mystery…
Matter – shaped and compressed energy, Einstein's
discovery history.

Reach Out, Touch other Energy Systems! Don't cut
 yourself off from The
Greater Source.

Conflict depletes human energy. Seek to Understand
 Who you Are.
Divine Source you are my Ultimate Security.
What does a connection to the Divine feel like?
Lightness, Buoyancy, A constant sensation of a higher
 Love!

Choose deeply and whole-heartedly!
Levitate to ecstatic states… Euphoria, Joy, Peace, and
 Liberation.
Experience Love without object, Love as constant
 communion with the Divine.

I am on a growth path alongside Mother Earth.
Connection, Trust, and Love… My spiritual mission.
I step beyond struggles to View
The Spiritual Purpose, Synthesize my truths to a Higher
 Level,
Uplifting All My Relations.

Personal Missions Guided toward Destinies… led by
 dreams, intuitions,
See the Light in every face, culture will accelerate
 spiritually.
Awake! No Psychic slumber!

God I Believe

Fear God, I cannot!
For, you become a Reflection
of the God, You adore.

I will not create a vengeful God!
God is Inside as well as Outside oneself.
True strength lies in one's
Struggle for Truth.

God Inside Me is Ultimate Love and Unity.
`God as I Understand –
Both Male and Female.
Parents of Humanity,
Together…
Mother God and Father God,
Always One God.

God as a real entity,
Is both Father God – static loving Knowledge,
And Mother God – engaging emotional Action.
Give up False gods, to get to the real One.

I am a reasoning primitive and ancient Gnostic,
A seeker of Truth, and Higher Love.
Genesis says, "We created man...."
Read it for yourself...use your own
God – given powers of reason,
To embrace an All – Loving,
Omnipotent God Consciousness.

Ponder the Duality of Humans...
Feminine and Masculine, yet one race –
humankind...
Made in the Image of God.

Join together, as God did.
Serve Community and Unity.
God is with us!

Save yourself, from yourself!
Absorb Unconditional Love, without object,
and Savation.
Find Light.

Inside

Panic replaces energy, folding me inward.
A mask smile lines my face
to cover dungeon deep fear.

Unstopable thoughts rise to mind,
and eat away at hope.
Darkness on a sunscaped day...
engulfs the joyful sounds of children playing
outside.

My own brain -- a barrier to the truth of free will.
A storm blew by, roaring thunder, and
opened the sky to Light.

Tears of clouds washed in natural bird baths
and lawn lakes.
It stopped suddenly as if to tease me with
it's impermenance.

An indoor brain cage has drenched me wet.
How do I ray-dry off inside?

Prayers

Trees blow up a breeze
of whispered calls to a mother in Spirit.

I remember the lavenders and greens
you brushed into Lilacs with ease.
Plants bloomed joy in your care.

Cats danced with you in the living room,
such laughter and life!
Now, silence falls when I cry your name,
but a soul in God's sky, you remain.

I dare not think of the body bag,
for it does not hold you.
In my dreams you giggle like a young girl,
and swirl in a land full of Angels that
twirl you in tune.

I may not understand why our time together
had to be cut so soon,
but the unmistakable love you showed me
grows with the days we have spent apart.
Our hearts reach through clouds and worlds,
forever connected.

Learning Curve

A sunscape
Fires spirals somewhere in space.
Seats fill with shapes...
She sinks into the back row.

The classroom canvas wraps her,
tying her spot in.
Inviting spring to drop
She draws flowers.

She stretches forward
Reaching for an answer
As if to beckon the sky
To pick her up BUT

Finds lips-locked in psycho-babble
Dry thoughts pound
Like a heart in her head
Sweat beads bubble in fear

Fear answers questions
Silently
Answer the question
Question the answer

Answer the question
Question the answer

What is the answer
What was the question?

I entered an answer
And it came out a question....

A question

Question Authority
Question Reality

Answer the Question
Question the Answer

Answer Authority
Answer Reality

Relate Authority
Recite reality

Author a question
Author reality

Move on
Move up

Move over
Over Authority

Over the question
The questions over

The answer is here
The answers the question

That's the question
What's the answer

That's the answer
What's the question

That's the answer
? huh?

Rain Release

Rain, wash over me.
Splash away the tears.
Drench me to the soul.
Let me feel your wet,

And not this pain inside.

Rinse me of this dirt,
That haunts me like a ghost
And takes away the most
Precious parts of me.

Rain storm down on me
Cleanse me, set me free.
Open up the sky,
Behind the clouds.
The sun shines
And tears dry.

Rain, you help the flowers grow...
Butterflies flutter and drink your dew
Help me do the same.

My spirit needs release
Spread joy and love, the core.
So help me
Help me help myself.
I will find a way.
I stand in your embrace,
Pieces of ocean
And pray.

Metamorphases

———— ✿ ————

Icy Spring
Snowy Summer
Rainy Autumn
Sunny Winter

———————————

In Dream Visible

Loves out there,
Seen the light
Walking in eyes
Of souls.

Bloom, glow, inlet heart breath;
Instrumental inspiration, spirit-art,
One slight-light-night touch,
Butterflies stomach flutter
Dawn dances,
Harmonious,
Chiming, blending soul-rythms…
A blue moon.

Pure prance tuned
Free foamy seas
Close not closed
Open not shut
Real not invented
True not unstable
Honest not artificial

Like Love ought, I thought,
Taught could maybe
Would be.

Loves out there,
Seen the light
Walking in eyes
Of souls.

Ode to Miles

———————— ✤ ————————

I womb-bear
New life
Circulating blood as one
For 10 months
We grow inside—
Me to mommy,
You like tadpole to frog.

10 months the latter,
a developing bundle...
crawl wiggles...
smile giggles...
breathes life into my heart and spirit.

You've opened my lids to the World
Of higher Love
Your bliss is my will...
To protect you ...
To encourage you...
To catch you when you fall.

———————————————————————

JULIA

━━━━━━━ ❧ ━━━━━━━

Precious gemstone
Who's generosity,
Strength and sparkling soul
Spirals yield-sheilding
Showers
Under her apron umbrella...

Feeding blessed solice
With plates of grace

A love-born
Cherished cherub—
Vital life-blood
Who's lifes work
Chimes light-emitting
Elevation—

A lighthouse
Guiding, lifting, cheering,
Lost seamen
To safe shores.

━━━━━━━━━━━━━━━━━━━

One

———— ✿ ————

One
Red Cardinal
Treetops…
Enchants, Conducts
Revives, Radiates…
A scarlet solo piccolo
That cartwheels human
Hearts to heights.

Feathers—petals soft
Syncronize,
Swoop, cascade
To seed feed…Refreshed
She soars her gamut—
silent clouds.

———————————————

Before and After Dreamscapade

———————— 🎵 ————————

Swim the freedom trail,
Sing-wing fly into the fairytale,
Dolphin twirl-whirl-tale,
Breathe the misty salt air…

Play-peel the cacoon,
Bay at the moon…

I'll be the rock,
You—the roll
Of the dice
Faded #8… infinity.

Fire-burn the gate
That holsds me as
Fate's bait.
Water will melt the wait
To heaven…

Where are elements
Are attached, yes, but…
All strings remain guitared.

Ode to Miles, Sunshine of My Life

Encapsulated inside caterpillar,
37 hours of labor
lead into indefinable love,
that has no label...

the elation infant birth
sunshine in a bassinet,
transformed bug to butterfly.

Moma's heart sinks and flutters
For healer cub, babies breath—
Enlightens heightens,
Points out
Light's way.

Miles angel wing-sings-songs,
His foot and hand impress hearts.

Priceless, he leap-frogs up...

Stretching out arms out like reaching for a kite
Adoring him in sight
Essential teeth of growth,
Bite.

I gaze at him
Through playpen walls,
Look to catch him if he falls,
Love his heart, spirit and all,
And follow as he crab crawls.

Hope for Unconditional Love

Unbind me Coffer!
Confining red-pumping veins
Into a sinking heart...
Turning, twisting, drop-popping
Stomach and skull.

Unblock silently concealed apparitions—
Toting dreams,
Consuming blazing twinkle-dazing...
A face
That swarms my brain.

Yet, I cannot see
Still, sworn to
This complextion like:

Solid concrete
For it fills a hole,
Whole and harmonious—

The ultimate concerto howl...
I, entangled
Look for:
Ladders, climbing tools,
Tops of mountains,
The limitless heavenly sky

And leap canyons and craters
Trusting twilight
Will yield me closer to my yearning
With each new day.

Blessed Wings

Gods devoted creations—
Guardian Angels—
Gifts, bestowed upon humankind.
Invisible... protect, defend, watch over...
Stretch feathers
Outspread shade-cover,
Disarm the veils of evil...

Butterfly around and
Surround us when hearing
Sirens sounds of anguish.
Net dark nights of horror,
Lay across our crumbled bridges
Undetectable, without thanks,
Credit, or gratitude needed.

Spiral, me, Angel!
Back up...
Lift my eyes toward
Heavens serenity, where
Gods loving peace can seed
In my heart
Anew.

Dark Spots

Enmeshed in their heavy darkness,
Bound to self-lies...
They lay and wake dead.
Godlessly deathing through earthbound life,
Over and over
Turning downwards in their graves.
They will not fly
Till they reach for the heavens,
For
God in all his Glory
Omnipotent Forgiveness that
Hover-floats in Love always...
Waiting for night to run from day.

Cross-Wise for Sylvia

Christ-mans intimate gift
Novus spiritus—Ecclesiastical
New Left,
Embraces wind crossing chrysanthemums.

Kindness in the current,
Cross over in exultation...
Embracing the cross walk...

Unclouded cloud,
Ink-clear soul
Seizing up a chrystal flag...

Luminous, clean, pure
Backboned, unstoppable
In heavens guidance...

Gods voice – inward travel
Outpouring other worldly
Quests...

Chrism bathing courage
She crush-crumples
Vile deception—evil—
And upholds God's love.

Fallen

—— ⚘ ——

Apple Tree Falls
Like crabgrass dewed
Pit-seeded,
It lies.
Fruit crushed under
It's own branches
Mush.
Dirty sauce.

Soul Reach

Spirit of color
Splatters loves drops on canvas.
A dancer teaching the air
To breathe.

Ears open to rhythm,
Eyes open to love,
Heart open to the great Creator.

A ball spinning on a still Earth.
Quiet in moments of dream.

Catching stars full of
The rays of father sky...

A Sundance radiating strength
In a dark world.

His passion explodes,
Informs his art endlessly
In tune with the Bear.

The Second Coming

Sword-swipe illusion,
Bring it down
Cast it out, throw it far.

Embrace, surround, engulf the Light.
Sing, Breathe Deep the Presence.

Revive, Rejoice, Revel
In the arrival.

Grip freedom in God
Stay sanctified
Within,
Withstanding wayward Souls.

Furious love – a lion and a lamb embrace.
Doors to Spirit revelation,
Trust pillars.

On my knees – a brickstone
Foundation.
Plummet the Depth of Grace.

Reach-ring Heaven's bells,
Process God's Heavenly Glory.

Grace

Love live a cool waterfall
On a hot dance.
Embrace me.

Single me out,
Love me as God loves you.

Blink

No more darkness...
Only light.
The sun rising and setting
Within everything in between
Still shines prism beach colors:

No wars,
No drugs,
No lies,
No faulty false buys...
Friendship,
Confidants,
Soul mates.

Bright white light—flower bulbs...
Music, drums, hands, dancing feet, souls, bodies
On Earth as it is in heaven.

Peaceful solitude in communal grace...
Real food, real people, real land, real life.
Self discipline without defense...
Animals talking in ears and listening
Without tears.

No dead-alive zombies, but
Visions of the Sweet Heavenly Father
And Mother God,
In our dream catchers.

Seeds of Love

Greet me with a kiss so holy...
Deliver me from doubt
Without you I am oppressed,
Regressed, digressive and veiled.

Touching beauty I swoon love.
Blessed comfort from your soul's arms
Makes me arrive.
I know that I am yours.

No affliction,
Just diction in word, in mind, in spirit, in body...
Altogether we are one Spirit in God.

I bear a lawless record but an honest heart.
Shaved sand saves the shore upon which
We will stand and lay together.

Call me to you as the wind blows
Us closer yet...I love you...let the
Palms meet us as our singlenesses embrace (a couple).

Morning Poem

Morning awakes us to each other.
Eyes drift toward eyes...
Hands to faces.
Oh, how we love to talk.

We Love talking-taking-in
Kisses.
Lying under covers warm,
Not worn but loved.
Private without privacy...
We talk like a body walk
On a sunny shore.

First Tradition

─────────── ༀ ───────────

See Might facing
Still more
Everyday and
Inviting you-dropped
From the heavens—
To Truth and Wild and Honesty.

Welcome radiant being
To our woods eye...
Advanced beginning.

I love you and
Prestige sharing the calm
Storm that rages within us both.
We massage awakening for loving
Mother God and Father God.

Unity is our message.
Behavior is the reaction—
Our family aware existing
Without denial of our or their
Love supreme, divine, holy.

─────────────────

Look at Me

———————— ✿ ————————

My Hand grasps the pen—
Eyes are half open until
I see you. My love for
You is as great as this universe.

I unfold and uncrumple
Just thinking of you, just
Smelling you, just almost
Touching you.

I yearn for your
Prescense...I long for
Your embrace in heart,Spirit,
And body. Be mine and let me
Be yours—your everything. Loosing
You would be like sand without a
Shore. No waves. Nothing. Know
My wet love. I am a dune
Without you.

Stare

Flattening the grass with my backside,
fingers comb the green summer growth.
Blue jays and sparrows hinge on leaves,
waiting to dash for a crumb.

Dragonflys change direction in a zip,
and bumblebees hover the blooms.
A grey tabby sits lazily on a second floor sill
while puffed white clouds top distant trees.

A winter woodpile lays covered
along side a hot tin watering can.
The breeze is slight against a shed
that holds tools for the coming autumn clean up.

My arm pillows my head and my feet cross
as I stare at a dying summer.
Soon the school buses will tell time
with fresh dressed students cornering stops.

I could lay here all day
and wait for the moon to bring on night's stars,
yet I know that each day that leads to dark
draws me closer to a season's end.

The pools will be lided and the rakes wait
for a summer's growth to fall.
But I must halt to the present
before it is gone.

Can't Throw Away

Torn floral seventies blue sofa
sinks into the floor.
They say it is your turn to hit the curb,
but your cushions and armrests hold
a fabric of memories.

Stringy ratted sides speak of the cat now passed.
A ringlet smack in the middle reminds me of
my son, before learning the ropes of potty training.
Blue and green marker etch his first art attempts.

Fur between seatings the vaccuum would not suck,
prove that the dogs also watched the T.V.
A slump on the left claims my favorite spot
and a drip of white wax tells the story of a winter
 blackout.

The feet have inched their way into hardwood,
small indents that record guests' welcomed visits.
Sun faded shoulders invited by warm seasons
contrast the colors of winter's grey skies.

A coffee stain outlines a day before coasters were bought.
This raggedy-Ann couch is marked with incidents
I cling to, though a new one awaits...
a future with more spots to fill up my brain.

Holding Hands

From the back,
they mirrored two lanky teenaged boys.
Autumn blew especially cold
through Golden Gate park.

Their oversized jackets
and black Air Force boots
held their body heat.

Cris engaging in true dyke form,
snuggled her long charcoal hair
up beneath the A's cap
Janis had gifted her with
for a three month commitment.

The city, on weekends,
had become tradition now.
This time, they carted
a two-month-old puppy.
She roamed leashless.

As they walked down the dirt trail,
past the peeling Eucalyptus trees,
the fearless canine galloped by their side,
occasionally nipping at Cris' baggy overalls.

Cris' eyes narrowed on the puppy,
like an overprotective mother.
Janis walked in naturally long strides,
and left Cris three steps behind.

The clumsy, leaf-chasing pup
insisted on greeting every passerby
with wet-tongued kisses.

"Wait up, Janis!"
Cris blurted while clapping her hands
against her thighs to draw the curious new puppy's
attention away from a squirrel's tail
and back to the stroll.

The mutt had no intentions of leaving her treasure,
so Cris craddled her like a football
up the sloping trail.

The 1980 Toyota awaited them
just up and past a hill.
Cris always perked up
during their usual stretch
back to the car.

She had survived one more trip
to the city
without Janis bugging her to hold hands.

The thought of two women walking
hand-in-hand
in the park at dusk,
made her stomache nauseous.

Heard stories of gay-bashing
scared her hand cold.
As a newbie to the "dyke scene"
she stomache struggled
with coming out to even strangers.

The pup squirmed to be let down.
The treasured tail was now twenty feet behind.
The ascent continued,
the puppy's tail wagging two steps behind Cris,
still three steps behind Janis.

The evening sky quickly darkened,
soon to match the canine's shadow black coat.
Janis abruptly stopped,
ran palm back and forth across
inch-long blonde hair,
while Cris caught to her step.

Janis fast glanced around,
then grabbed squeezed Cris' hand.

"Don't touch me!"
Cris girl-shrieked.

Janis pleaded into Cris' dark eyes.
"Relax, we're in the gayest city around!"

The dog busily chewed on litter,
an old McDonald's wrapper.

The green stare of Janis' eyes
caught Cris.
Once again, Janis hand squeezed her.

Cris took in long slow breathes,
and exhaling, tightened the grip,
but picked up the stroll's pace...
and pulled Janis from her stand-still position.

The puppy resumed nipping and tail-wagging,
from just beyond their now even steps.
Heat rose from Cris' sweating palm.
to her flushed face.

Her grip went from a tense tight grasp
to a relaxed and natural hold.

Glass shaterring in the distant shadows by the car
burst the silence.
A deep male voice screamed obsenities,
and their hands squeezed tight and tense again.

A patch of shrubs spawned a tall figure
running off as if to avoid an explosion.
Another shadow popped over a dark green wall.

As the phantom emerged,
a man limped toward them,
cane hooked to his arm,
headed away from the fugitive.

With short quickened breaths,
Cris asked, "What do we do?"

In a forced whisper, Janis eeked out,
"Grab the puppy! Turn around! Walk the other way!"

The pup viewed the man as a playmate
and sprinted in his direction.

"Come, come back!"
But a smoker's scruffy voice invited the dog
and limped toward her.

This was the kind of man Cris' mother
had warned her about,
yet her own motherly instints vitalized.
She jogged toward her "baby."

Janis trotted slow and cautiouly toward an uncertain
 situation.
Fully viewing the man,
Cris' fears doubled
and she waited for Janis to catch up.

She stretched her arm out
until she felt Janis' strenght in her hand.

Hand-in-hand,
they slow approached the stranger.

A shaggy beard and mustache
harbored pieces of old food and mucus,
an over-weathered jacket heightened his tall frame,
dirt stained jeans hung loosely from his waist,
and the cane swung back and forth from his forearm.

His eyes were dark,
almost all pupils,
and stared glossy wide in their direction.

Swearing to himself and
reaching down with long shaking fingers
to pet the pup, he nearly fell over.

She nipped at his stained brown shoes.
All reached hand shaking distance.

A mixture of alcohol and urine
lingered like fog around the figure.
Cris lip-bit as the man regained his footing.

Janis final squeezed Cris' palm
before leaning forward, and bending down
to scoop up the pup.

The stranger began a loud ranting sputtering speech:
"Hey, you know...that other guy...
he's got a drug problem...and a people problem, too...
he's been to my mama's house, my sister's house...
stole from 'em, too...
now he's trying to ignore me...
walked right by...
didn't say two bits...
we used to hang as little kids...
but what do you care...
only your doggie likes me..."
ending his words with a quieter utter.

Cris toughened up and looked him eye to eye.
"You don't deserve that kind of disrepect!"
The man just whimpered,
"Nobody loves me now...
just your cute little dog!"

He moaned and swore for another minute
before Cris elbowed Janis.
Night raced the fog,
blurring the background.

They sighed in relief as they realized
that they and their pup were safe
and they could outrun this shattered man
if they had to...

but someting magical had struck these women that night.
Hand-in-hand they had conquered a fear.

Cris played with the rim of her cap
as the man began to tell his life's story
to them as if a man before a preacher
on his death bed.

Then Cris gestured,
"Here, take my hat...
It'll keep you a bit warmer."

Her long strands fell in one wave
across her back.
Janis released the squirming puppy
and watched the sullen face light up.

"The Oakland A's, man, cool...
my mama's from Oakland!"

While he adjusted the cap to his head,
Cris grabbed Janis' hand
to escort her up the hill
and shouted back to him,
"Now don't let anyone ignore you like that!"

Cris planted a soft-lipped kiss
on the hand that she held.

Swords to Flowers

Weapons form flowers
when obstacles are befriended.
Experiences inform us to what we are glued.

Perception can change an arrow into a blossom.
Reality is within the direction of our hearts.
Interference in sought harmony occurs
and we feel attacked, mauled by chaos.

From time's beginning only confusion
can invade our imagined peace.
Our enemies reside within us,
creating solids in the material
that want us to chase the simple now away.

Whereever we run, the lesson follows.
To avoid unpleasant encounters,
we separate, pull back or shut down,
unaware it is are own retreating we are fighting.

When squeezed by negativity,
can we turn to see our own humaness?

When certainty and security are threatened,
we grasp for pleasure and hide from pain.
Blotting out the awkward,
we escape different dimensions of truly being alive.

In losing all, we fall through space,
without knowing where we are
or what could be next.

Our reaction is to flee back to old bewilderments,
for at least they are recognizable.
The old personality seems to fit since it has been worn so
 long.

Refusing to let go to the unknown,
we march to an old habitual drum beat.
Everything must be predictable to be real in an unwise
 mind.

Emotions are as enormous as wide open spaces,
and those that are unwanted can become our teachers.
There is fresh air in interruption,
rather than trying to smooth out a rough ride.

A desire for perfection undermines challenge,
and to live is to die,
over and over again,
awakening fresh each time
with each sword becoming a flower.

Surrendering to Truth

Seeking the ultimate question of:
"What is Truth?"
no answer can come.

Listen for the silence,
not because Truth does not exist,
but because it is vastly undefinable.

Though confined to a single word,
language cannot define it completely.
It cannot be said,
but only be.

No ladder reaches higher than Truth,
understanding is it's perch.
It cannot be bought or stored,
for all are owned by it in heart.

Reality is a mere interpretation of
known thought...the mind has marked it
in colors the eye can see.

Many eyes create different pictures,
and thus multi-realities.
Truth is singular and cannot come from
an organ in the human head.

Mind separates and dissects
making reality dependant on
that which develops despite existence.

Interpretation grabs Truth
to mistakingly make it a "thing."
Ego acts, manages and possesses
to create the definable and
poisons the True.

The crystal purity of Divinity
closes to the dark hole of the mundane.
Nothing is solved when falsifying by approximation.

Truth's presence exists in the absence of untruth.
No answer in words is possible
when fundamentally, the substance
of existence is that which is.

The mind always searches to provide
answers to questions,
but how can it answer with Truth,
when the answer is unknown.

In knowing, there is no need
for the question.
The brain can only supply memories...
of impressed reality repeated mechanically.

This is only borrowing, not Truth.
Our heads hoard knowledge,
accumulating the superficial
and pretending to know.

Develop the insight to cut mind in two...
and arrive at a moment of authentic experience.
Let Consciousness reflect as if
in a windless lake, clear and undistorted.

Thoughtless awareness embraces the silence.
Crowded mind releases the grasp
of thought holding yet another thought.

Surrendering Ego is an understanding.
You are not separate from the Universe.
We are a combination of the elements.

Consciousness gone wrong
becomes self-conscioucness.
It is a human dilemma.

Surrendering is never found,
for in becoming a surrenderer,
one is separating oneself from the whole.

The Ego is constantly striving, starving
to falsify the Truth.

In being goal-oriented,
it remembers what is no more and
imagines what is not yet.
The Present is thus lost.

Surrender grows in emptiness.
If time enters, the now disappears.
The only freedom is
to be free of the self.

This self can fragment itself,
becoming watcher and watched,
but never seeing the freedom
in simply being the space beyond
without manipulating.

One does not always have to grab and grasp at life.
Desire creates frustration,
because no thing ever satisfies.

Without expectation there is no failure.
Let life be a process...a verb.
Seeing into the reality of Truth,
it disappears.

Know No Knowledge

Taste the Nothingness beyond.
Unfold the heart to a disappearance inside.

True joy is overflowing with emptiness.
Forms undo while the undefinable remains.

Remove obstructions to clear a path to the invisible.
Through awareness, the formless is sensed.

Opposites are no longer polar.
Tension melts with the absence of conflict.

"Yes" and "no" dissolve into unity.
Positive and negative merge
until there is both together as nothing.

The center retracts.
Do not define youself as the clouds
in the freedom of space and sky.

No idea should ever define you,
nor knowledge confine you.

Perception through projection declines a state of purity.
Bias is a conclusion that throws shadows.
Gathered opinion only blinds.

Knowledge is tiny compared to existence.
Words and more words create great illusion.
Transparent nothing matches that which cannot be known.

When naked of knowledge, a knowing comes.
Silence is the transformer,
where with nonfunctioning Truth arrives.

Escape those things outside you
to discover the innocence within.

In openness, intelligence of the Universe appears.
Fear will keep you from the beautiful unknown.
Without Ego fear cannot exist.

Instead, we are one with existence.
When spontaneous, one responds
rather than reacts and virtue is prevalent.

Unpredictability is a key to freedom.
To be rehearsed is to live in the past
and steals dignity away from the human experience.

Acting out of nothingness,
you are authentic, valid and true.
Relevance stems from our deepest core.

Nothingness leaves no residue,
no traces or footprints,
like a person living in the sky
and never looking backwards
because all is complete.

Soul Nature

Seen from the moon,
the vast ocean seems calm and unwavering.

Focusing in from foot's distance,
waves curl up and crash...
each an unmatched individual,
yet unseparate from the sea itself.

This unending water of possililities
is the realm of Soul.
Every raising and falling of ocean
cannot be catured,
for it is part of a deeper, larger whole.

Only in observation is a tide
widening or shortening a shore.
The sand is simply a point of reference
for an experience of size of beach.

We interpret where to place our blankets,
according to time.
The sun also rises and sets
in pairs of human eyes,
although it is sitting in space.

Light's abscence illuminates
the heavenly stars,
although always having been there...
just unknown.

You cannot peel the cosmos
from the infinite,
for all,is by definition,
universal.

Window

———— ✿ ————

Staring through a window,
I process,
I learn,
I begin to unfold...
Layers upon layers,
The truth inside.

Magical Being

We can find the entire Universe inside,
for the world lives in us.
Where there is oneness,
no problems can hold.
To believe only in what we see and feel
creates opposites of untruth.
Somehow, there is a longing for meaning.
Wonder not what we see,
but why we see it.
Beyond a limited self
is the boundless Self.
The elusive voice that is one's own
calls us to pierce the mask of mortality.

Emotions merely react to sensation,
while the mind's delayed reaction
shuffles and categorizes memories.
We name this "good" and that "bad"
rather than allowing that which is
to simply be.
All is Myself.

Love's light shines through self-acceptance.
It cannot be acheived through effort.
The mind and emotions are entangled
in selection.
That which we fear, we reject...
using up great energy in the choosing.
No room is left for silence.

Delicate life's appreciation is crowded in noise.
A looking within brings peace.
Don't argue with the mind,
but see instead.
What captures inner sight
will manifest in the outer world.

Innocence is natural
when not covered by self-image.
We complexly layer our image,
built higher over the years,
and cloud our true Selves.
Ego distracts from that which is truly there.

The world becomes dull with labels
and steals each moment's newness.
Contemplation is no longer all-absorbing.
In transforming to the infinite,
you can expect everything to be fresh.

In participating with innocence,
you see the unexpected and unconditioned.
Your vision breathes life
into that which is seen due to awareness.
Innocence is regained when
you view all of creation with love lenses.

Become a witness to a changing world
and search to merely see and understand.
Awake from a dreamless sleep
to the formless.
In every atom lives an ever-conscious,
universal intelligence.

When fully present nothing is misunderstood.
Pure knowingness does not rely on external facts.
That which comes into view may change,
but the seer does not.
Though knowledge is innate,
mortals use it to dissect and separate.
Violence is hidden in rationality.

Awareness unites in one seamless flow
that which the mind claims as "out there."
Through separation,
one is made to be many.
Light is awareness that
knows no boudaries.
It is not dependent on perception,
but simply exists.

The seer is conciosness behind an eye
that births the world through the senses.
Information becomes storable in
awareness made manifest.
The only thing left to forget is yourself.
There is no real division between body and universe.

Recognition is not the same as knowing.
It only traps an unconditioned spirit inside conditions.
We are not limited to our bodies,
for we are consciosness taking form.
Thoughts fly so fast,
they may as well live in the air.
We are not what we think.

When intensely alive,
the act of observing is interupted
with a glimpse at the observer.
The seer is timeless in a time-bound experience.
The mind stops it's chattering
and cannot be moved by thinking, talking, or doing.
When we are fully human,
reality cannot be defined...only experienced.

We are surrounded by the timeless,
yet we cut the timeless into recorded pieces
and disqualify eternity.
Death is a lie we cling to and fear.
The universe is energy that cannot be destroyed.
There is no beginning or end.
The formless within the form
is immortality amoungst the mortal.

Consciousness survives death
and transformation is a construct of the mind.
Rationality defends death when
immortality is the core of the human condition.
Memories are personally contrived
and seperation an illusion.
We are all a flowing field of Light.

It is the Ego that creates isolation by creating gaps
and blocking a full view.
Universal consciousness is shared
and lives forever embracing all thought,
all emotions and all experiences.
See the unreality and unreliability of memory.
Everything in description is dependant on relativity.
Reality is not a viewpoint.
We fragment ourselves behind a curtain,
and hide our truly infinite fabric.

Although we believe we are machines
that have learned to think...
we are actually thoughts that learned to manifest
in the physical world.
DNA grew out of an impulse for life.
In the seen and unseen,
is compressed billions upon billions
of years of all the intelligence of the universe
into every moment.
The womb of creation is oneself.

Only love dissolves the impure and false.
It has the ultimate power,
for it draws everything unto itself.
To walk in the light of love
is to look inward and dispell all fear.
To be loved unconditionally,
one must not place conditions.
Real love does not come and go,
for it is unchangeable.
Self-acceptance must come first,
as an inner force seen inside oneself.
When trusted, this true type of love
brings peace rather than possesion.

There is a naturally tendency towards growth.
Eternity upholds life and nurtures it
thus, this life is inextinguishable.

About the Author

Sandra Wojciak lives in New Britain, CT with her son, Miles, and many animals. She loves to play with words often combing two to make one word.She graduated UC Davis with a B.A. in English with an emphasis on poetry. She also studied at Central Connecticut State University, where she earned a teaching certificate in English. She likes to combine the serious with humor and everyday life with the spiritual.